PICASSO GIRL BEFORE A MIRROR

ANNE UMLAND

D1275539

THE MUSEUM OF MODERN ART, NEW YORK

AT SOME POINT ON WEDNESDAY, MARCH 14, 1932, PABLO PICASSO STEPPED BACK from his easel and took a long, hard look at the painting we know as *Girl before a Mirror*. Deciding there was nothing more he wanted to change or to add, he recorded the day, month, and year of completion on the back of the canvas and signed it on the front, in white paint, up in the picture's top-left corner.[1] Riotous in color and chockablock with pattern, this image of a young woman and her mirror reflection was finished toward the end of a grand series of canvases the artist had begun in December 1931, three months before.[2] Its jewel tones and compartmentalized composition, with discrete areas of luminous color bounded by lines, have prompted many viewers to compare its visual effect to that of stained glass or cloisonné enamel. To draw close to the painting and scrutinize its surface, however, is to discover that, unlike colored glass, *Girl before a Mirror* is densely opaque, rife with clotted passages and made up of multiple complex layers, evidence of its having been worked and reworked.

The subject of this painting, too, is complex and filled with contradictory symbols. The art historian Robert Rosenblum memorably described the girl's face, at left, a smoothly painted, delicately blushing pink-lavender profile combined with a heavily built-up, garishly colored yellow-and-red frontal view, as "a marvel of compression" containing within itself allusions to youth and old age, sun and moon, light and shadow, and "merging . . . one of the most pervasive cultural myths about women inherited from the nineteenth century, the polarity between virgin and whore, archetypes that haunted Picasso from his earliest years."[3] Her reflection, on the right, further complicates the picture, introducing a shadowy, introspective doppelgänger into the painting's compressed and chromatically overheated space. The intensely mysterious relationship between the two figures is the primary subject of the painting, which reinvents the time-honored artistic theme of a woman before her mirror in radically modern terms, tinged by the mortal associations of traditional Vanity images and by powerful psychic overtones.

Pablo Picasso (Spanish, 1881–1973). *Girl before a Mirror*. Paris, March 14, 1932. Oil on canvas, 64 x 51¼" (162.3 x 130.2 cm). THE MUSEUM OF MODERN ART, NEW YORK. GIFT OF MRS. SIMON GUGGENHEIM, 1938

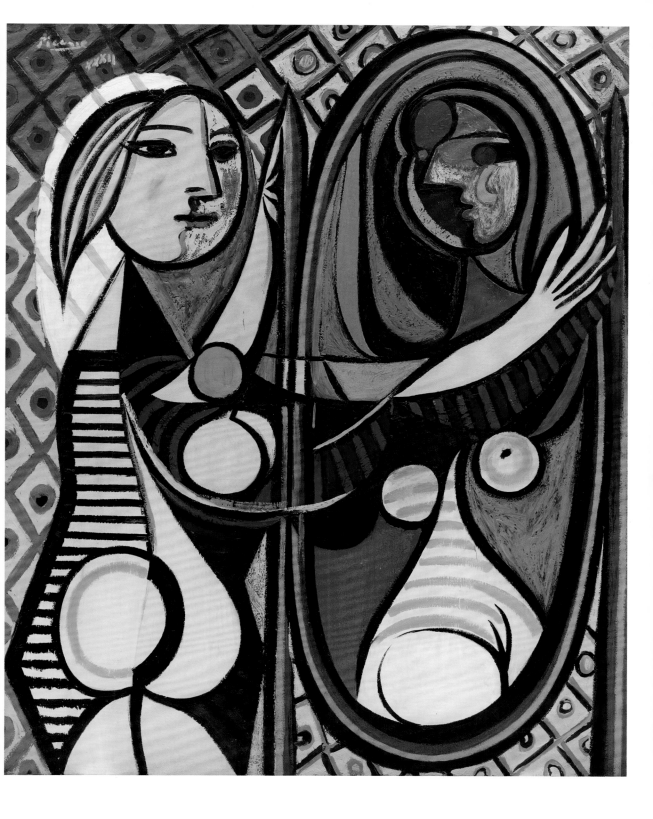

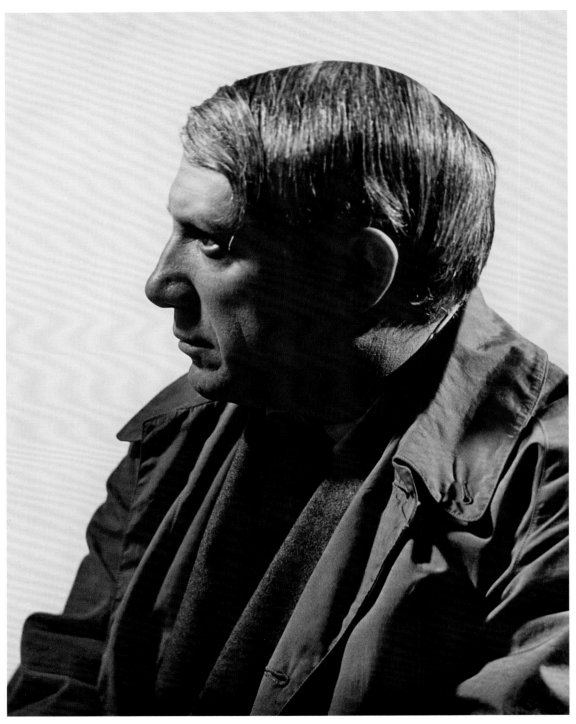

FIG. 1. Man Ray (American, 1890–1976). *Pablo Picasso*. Paris, 1932. Gelatin silver print, 11¾ x 9¼" (29.8 x 23.2 cm). THE MUSEUM OF MODERN ART, NEW YORK. GIFT OF JAMES THRALL SOBY, 1941

"The body of work one creates is a form of diary," Picasso told the art critic and prominent publisher Tériade a few months after completing *Girl before a Mirror*.[4] His words invite us to think about the painting as a visually extravagant form of diary or journal entry that allows us to peer into his art and life at a particular time and place. Picasso had turned fifty the previous year [FIG. 1]. Although he was extraordinarily successful by any standard measure, the rapidly approaching opening of his major retrospective exhibition at the Galeries Georges Petit, in Paris, scheduled for June 15 of 1932, inspired him to work at a fever pitch, believing that his contemporary relevance and artistic legacy were on the line.[5] *Girl before a Mirror* was clearly painted with this make-or-break retrospective in mind. According to Alfred H. Barr, Jr., The Museum of Modern Art's first director, Picasso said he "preferred this painting to any of the others in the long series he had completed that spring."[6] Although he did not elaborate, part of the reason must have had to do with the painting's dazzling visual and thematic complexity, which exceeds that of the many other splendid canvases Picasso created for the Galeries Georges Petit show.

THE MUSE

The blond hair and pink-and-lavender profile of *Girl before a Mirror*'s female protagonist represent the distinctive features of a young woman Picasso had fallen passionately in love with five years before, whose name was kept secret for decades from all but those who best knew him.[7] Years later, this woman recalled the circumstances of the first time she met the artist, on Saturday, January 8, 1927, a cloudy Paris winter day, with the type of vivid clarity memory accords life-changing events:

> I met him in the street. I was going shopping: I was going to buy a little collar for a blouse. He was looking at me. He had a superb red and black tie on, which I still have, incidentally. I thought it was very handsome. He gave me a nice smile and then he accosted me. He said to me "Miss, you have an interesting face. I would like to do your portrait. I have the feeling we will do great things together." It was six in the afternoon. He said to me "I am Picasso." He showed me a thick book about himself in Chinese or Japanese. He thought it was very funny because you couldn't read his name on the book. He said to me "I would like to see you again."[8]

Born on July 13, 1909, Marie-Thérèse Walter was seventeen years old on the day she met Picasso.[9] The artist was forty-five, had been married to the Russian former ballerina Olga Khokhlova for more than eight years, and had a five-year-old son,

FIG. 2. Photograph by Picasso of Marie-Thérèse Walter with her mother's dog, Dolly, Alfortville, France, c. 1930. ARCHIVES MAYA WIDMAIER PICASSO

FIG. 3. Pablo Picasso (Spanish, 1881–1973). *Guitar*. Paris, April 27, 1927. Oil and charcoal on canvas, 31⅞ x 31⅞" (81 x 81 cm). MUSÉE PICASSO, PARIS. REMITTANCE IN LIEU OF INHERITANCE TAXES TO THE GOVERNMENT OF FRANCE BY JACQUELINE PICASSO

Paulo. Despite this, or perhaps because of it, Picasso saw Walter again only two days later, and from then on their encounters grew more frequent. By 1932 she had become a well-established and profoundly transformative presence in Picasso's art and life [**FIG. 2**].

The first traces of Walter in Picasso's work appear in the form of crypto-grams [**FIG. 3**]. Perhaps thinking back to his early Cubist years, when he wrote the name of another secret lover onto the surface of his art, Picasso created sev-eral small, schematic paintings that nominally depict the classic Cubist subject of a guitar but whose primary protagonists are the letters M and T, suggestively

overlaid, conflated, and combined.[10] The following summer, when Walter clandestinely followed Picasso and his family on their summer holidays in Dinard, in Brittany, Picasso snapped a photograph of her on the beach that captures her unique physical presence [FIG. 4].[11] "I found Marie-Thérèse fascinating to look at," recalled Françoise Gilot, an artist and Picasso's companion from 1944 to 1953, who met Walter in the 1940s.[12]

> I could see that she was certainly the woman who had inspired Pablo plastically more than any other. She had a very arresting face with a Grecian profile. The whole series of portraits of blonde women Pablo painted between 1927 and 1935 are almost exact replicas of her. . . . Her forms were handsomely sculptural, with a fullness of volume and a purity of line that gave her body and her face an extraordinary perfection. To the extent that nature offers ideas or stimuli to an artist, there are some forms that are closer than others to any artist's own aesthetic and thus serve as a springboard for his imagination. Marie-Thérèse brought a great deal to Pablo in the sense that her form demanded recognition.[13]

Picasso's representations of Walter range from instantly recognizable portraits to radically abstracted figures. Two works from 1928 convey a sense of early stylistic extremes. A closely observed and tenderly drawn lithograph of Walter [FIG. 5] — included, without any reference to the identity of the subject, in a 1928 book on Picasso's work written by his friend, the dealer and collector André Level — has a magical quality.[14] The tight cropping brings the soft cheek, curved lips, distinctive nose, and luminous eyes of Picasso's model into breathtaking proximity, testifying to his intimate familiarity with the defining features of her face. The tiny *Bather and Cabin* [FIG. 6], painted in August 1928, suggests another way that the artist made aesthetic use of Walter's presence in his life. Filled with playful sexual innuendo — the dropped towel, the double entendre of a key inserted in a keyhole — it conjures up heated trysts in beachside cabanas while introducing a new vocabulary of pictorially rendered abstract-yet-figurative sculptural form.[15] The bather's nude body (behind which, at right, lurks a shadowy, silhouetted figure bearing the artist's profile) comprises seemingly separable, softly contoured volumetric shapes.

A few years later, after purchasing Château de Boisgeloup, a country estate about forty miles northwest of Paris, where he was able to set up a sculpture studio, Picasso returned for the first time in years to intensive modeling (as distinct from making welded metal assemblages).[16] The years between 1931 and 1934 were one of the most remarkably productive periods of sculpture making in his career.[17] The features of many of Picasso's plaster busts from the early 1930s, for all of their abstract simplifications, evoke Walter's. They vary from the

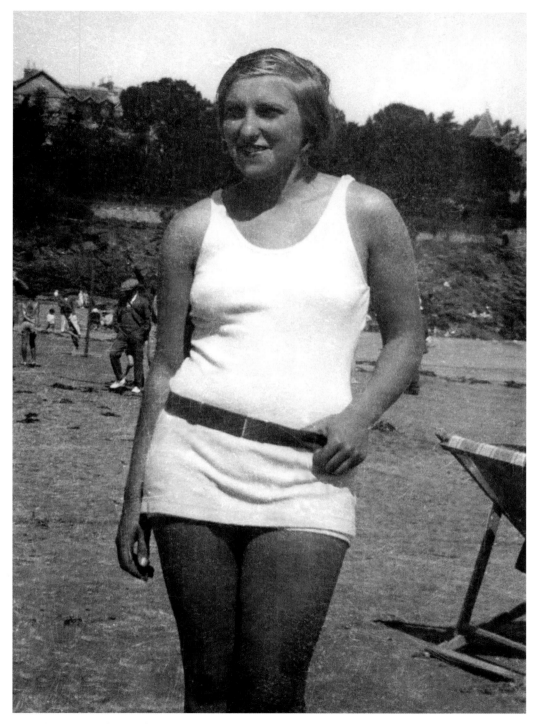

FIG. 4. Photograph by Picasso of Marie-Thérèse Walter at the beach, Dinard, France, August 1928. ARCHIVES MAYA WIDMAIER PICASSO

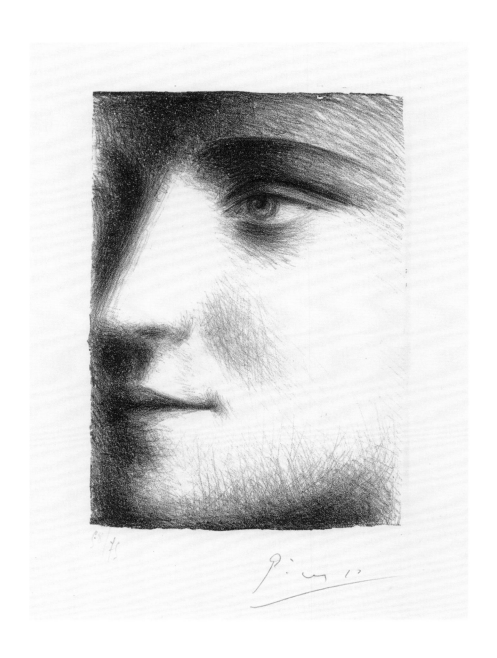

FIG. 5. Pablo Picasso (Spanish, 1881–1973). *Face of Marie-Thérèse*. Paris, c. October 1928. Lithograph. Publisher: Galerie Percier, Paris. Composition: 8 x 5⁹⁄₁₆″ (20.3 x 14.1 cm). THE MUSEUM OF MODERN ART, NEW YORK. GIFT OF ABBY ALDRICH ROCKEFELLER, 1940

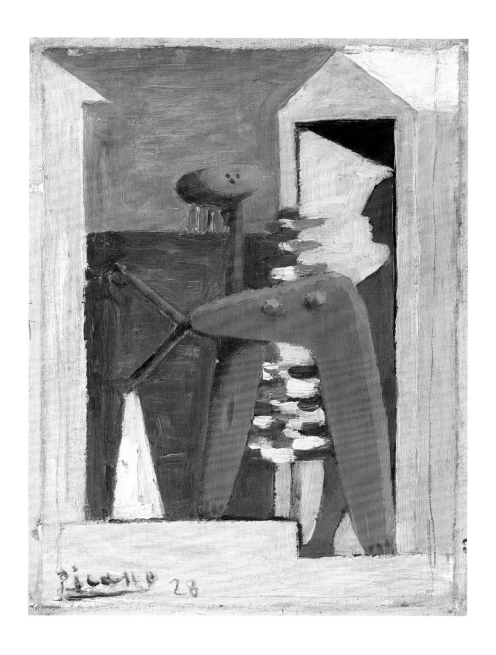

FIG. 6. Pablo Picasso (Spanish, 1881–1973). *Bather and Cabin*. Dinard, August 9, 1928. Oil on canvas, 8½ x 6¼"
(21.5 x 15.8 cm). THE MUSEUM OF MODERN ART, NEW YORK. HILLMAN PERIODICALS FUND, 1955

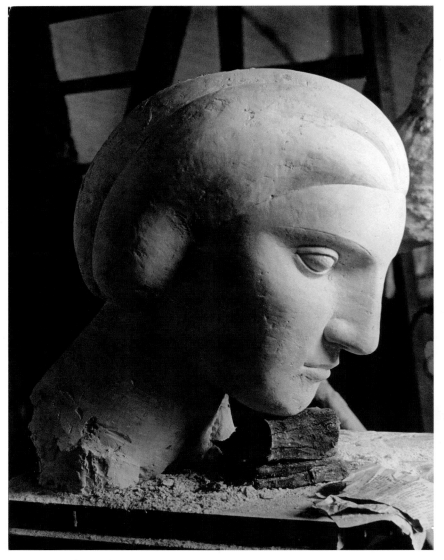

FIG. 7. Plaster of *Head of a Woman*, Boisgeloup, December 1932. Photo by Brassaï. ARCHIVES PICASSO, MUSÉE PICASSO, PARIS

relatively straightforward likeness of *Head of a Woman* [**FIG. 7**] to the exaggerated volumes of *Head of Woman* [**FIG. 8**] and *Bust of a Woman* [**FIG. 9**] to the monumental *Head of a Woman* [**FIG. 10**], with its engorged nose, swollen cheeks, and distended mouth.

The sexualized facial features of the latter three sculptures, in which noses and mouths double as male and female sex organs, demonstrate Picasso's love

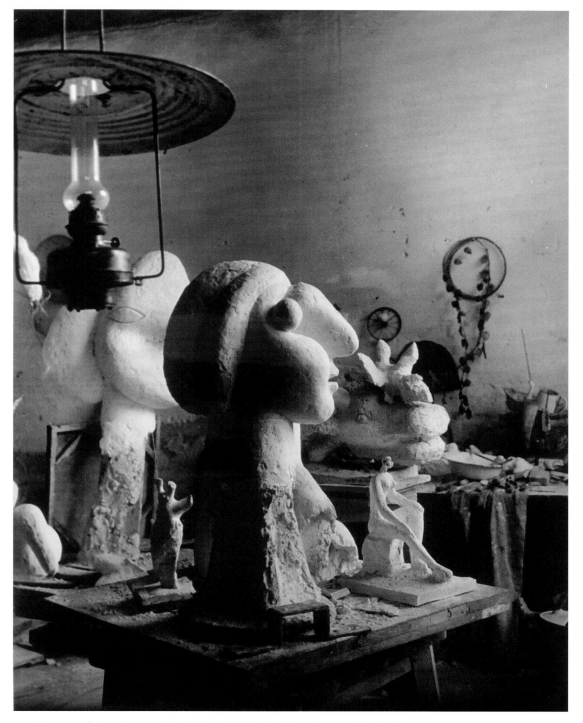

FIG. 8. A corner of the sculpture studio at Château de Boisgeloup, December 1932. Photo by Brassaï. ARCHIVES PICASSO, MUSÉE PICASSO, PARIS

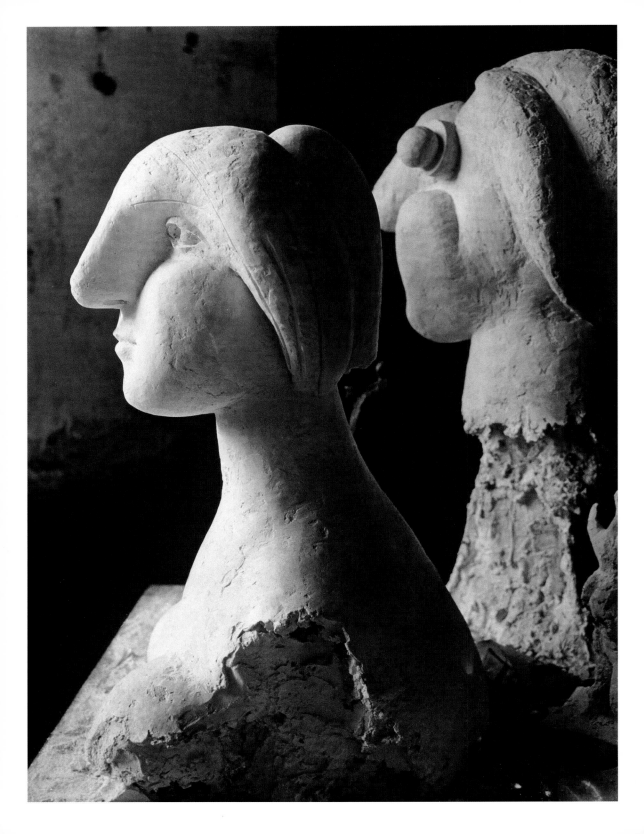

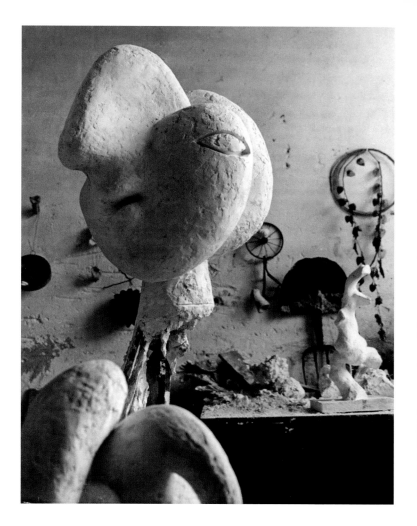

FIG. 10. Plaster of *Head of a Woman*, Boisgeloup, December 1932. Photo by Brassaï. ARCHIVES PICASSO, MUSÉE PICASSO, PARIS

of visual punning and his remarkable ability to render the familiar radically strange. "I seek always to observe nature," he commented in 1945. "I cling to resemblance, to a deeper resemblance, more real than the real, attaining the surreal."[18] Although Picasso's definition of "the surreal" was different from that coined by André Breton, the Paris Surrealist group's leader, in 1924, the Surrealist poets' and artists' rejection of contemporary social and sexual mores, along with their celebration of "convulsive beauty" and "mad love," surely were among the factors that helped propel Picasso's sculptures and subsequent paintings beyond the visual specifics of Walter's features into the realm of great, erotically charged art.[19]

OPPOSITE: FIG. 9. Plasters of *Bust of a Woman* and *Head of a Woman*, Boisgeloup, December 1932. Photo by Brassaï. ARCHIVES PICASSO, MUSÉE PICASSO, PARIS

PAINTER–SCULPTOR

December 1931 found Picasso back from Boisgeloup and in his Paris studio at 23, rue La Boétie, where he began the series of paintings for his Galeries Georges Petit retrospective that would climax with *Girl before a Mirror* the following spring. Among the first of these works was *The Sculptor* [**FIG. 11**], which he completed on December 7, 1931. This oil painting on plywood, which offers a more resistant surface than that of canvas, features a bearded sculptor, Picasso's alter ego, seated at right. Immediately to his left appears a sculpture of a seated figure whose pose mirrors his own, while directly across from him is a female bust on a pedestal. The sculptor, whose face contains frontal and profile views, peers out at us with one eye and with the other stares fixedly at the bust, which bears a marked resemblance to Picasso's plaster *Bust of a Woman* [**FIG. 12**] and to Walter, Picasso's flesh-and-blood muse, whose profile appears again in the tiny picture-within-a-picture at upper right, above the sculptor's head.

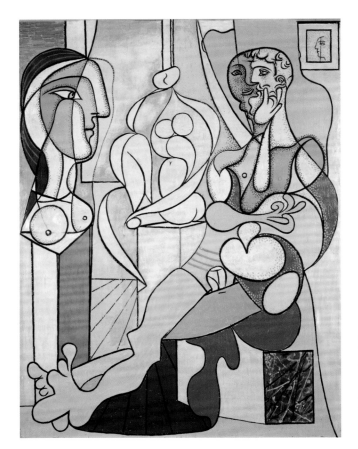

FIG. 11. Pablo Picasso (Spanish, 1881–1973). *The Sculptor.* Boisgeloup or Paris, December 7, 1931. Oil on plywood, 50¾ x 37¾" (129 x 96 cm). MUSÉE PICASSO, PARIS. REMITTANCE IN LIEU OF INHERITANCE TAXES TO THE GOVERNMENT OF FRANCE BY THE ESTATE OF PABLO PICASSO

The painting can be interpreted, on one level, as a meditation in painted form on the art of sculpture and on the particularly slippery relation between this latter category of art making and life, hinting at the profound impact Picasso's three-dimensional work in the Boisgeloup studio would have on his two-dimensional pictorial practice, particularly in the canvases created for the Galeries Georges Petit show. It also graphically links artistic creativity to sexual arousal, as illustrated by the sculptor's erection, which rises up between his crossed and extended legs. The implication is, as art historian Elizabeth Cowling has written, "that passionate love inspires great art and that making art and making love are profoundly related activities."[20] Here, however, Picasso only diagrams the situation; it is in the paintings that follow *The Sculptor* that he begins to align painting's ties to sight, distance, and observation with sculpture's insistent physicality and its intimate alliance with touch in order to create a new, radically carnal form of art.

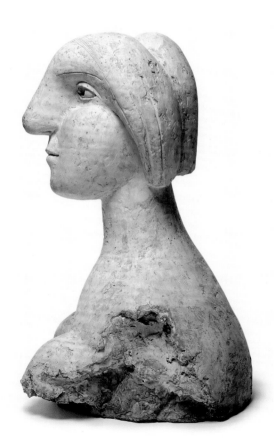

FIG. 12. Pablo Picasso (Spanish, 1881–1973). *Bust of a Woman.* Boisgeloup, 1931. Plaster, 30¾ x 18⅛ x 18⅞" (78 x 46 x 48 cm). PRIVATE COLLECTION

In January 1932 Picasso began to produce paintings fast and furiously. Three works completed within days of each other at the end of January establish a gamut of emotional and figurative extremes, ranging from the monstrous, gorgon-eyed, predatory woman featured in *Repose* [FIG. 13] to *The Dream*'s self-pleasuring, languid sleeping beauty [FIG. 14], whose bisected head creates the impression of a phallus resting on her nose and lips, to *Woman with a Book* [FIG. 15], an alert, upright courtesan, dressed in an embroidered gown, with spherical breasts and nipples peeking out over the top of lace corseting. As the days and weeks went by, the lines and contours in Picasso's paintings became more fluid and boldly graphic. The luminous white plasters of Boisgeloup appeared, as the sole figurative protagonist in *Still Life with Tulips* [FIG. 16] and as a watchful guardian presiding over the creamy, lavender-pink nude stretched in horizontal abandon across *Nude, Green Leaves, and Bust*'s foreground [FIG. 17], with head thrown back, throat exposed, breasts lolling. Only the flame-shaped swoosh of yellow hair and distinctive profile, exaggerated and simplified, remain as attributes specific to Walter.

In *Nude in a Black Armchair* [FIG. 18], completed on March 9, 1932, and *The Mirror* [FIG. 19], completed on March 12, just two days prior to *Girl before a Mirror*, Picasso moved in closer to his subject, pulling her body up against the canvas surface, seeming to approach it from above and from the side, circling it with his eyes and with his brush. In *The Mirror*, as in *Girl before a Mirror*, he introduced the device of a cheval or *psyché* mirror — a type of mirror that swivels, allowing it to be tilted at different angles — as a means of showing more of his model's body at once. She is depicted meltingly in the foreground, with long sweeping brushstrokes that evoke the physical abandonment and deep relaxation of sleep, and again above, in the mirror, which is positioned to capture the ambiguously curving shapes of what could be hips and buttocks, reversed and rising up white against a hot red ground.

When Picasso's dealer and friend Daniel-Henry Kahnweiler visited the artist's studio on March 17, 1932, he reported having seen

> two paintings . . . which he had just finished. Two nudes, perhaps the most moving things he's done. "A satyr who had just killed a woman might have painted this picture," I told him. It's neither cubist nor naturalist. And it's done without painterly artifice: very alive, very erotic, but the eroticism of a giant. For years Picasso hasn't done anything like it. He had told me a few days before, "I want to paint like a blind man, who does a buttock by feel." It really is that. We came away overwhelmed.[21]

FIG. 13. Pablo Picasso (Spanish, 1881–1973). *Repose*. Paris, January 22, 1932. Oil on canvas, 63¾ x 51¼" (161.9 x 130.2 cm). THE STEVEN AND ALEXANDRA COHEN COLLECTION, CONNECTICUT

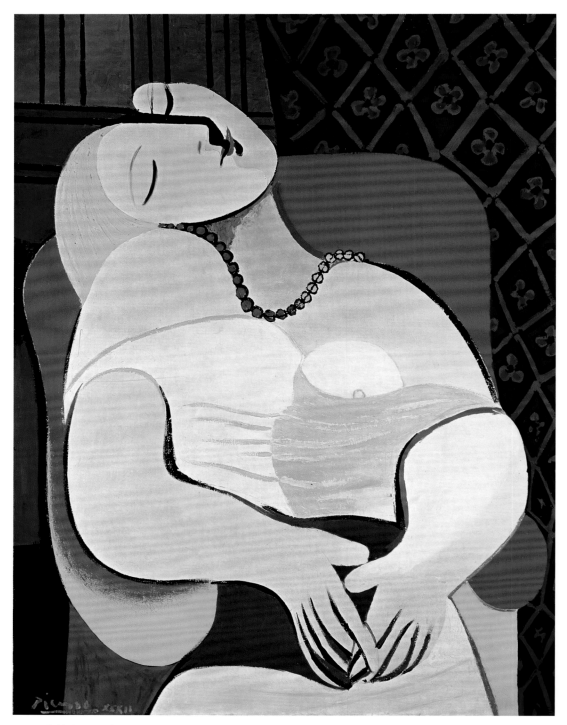

FIG. 14. Pablo Picasso (Spanish, 1881–1973). *The Dream*. Paris, January 24, 1932. Oil on canvas, 51⅛ x 38¼" (130 x 97 cm).
PRIVATE COLLECTION, NEW YORK

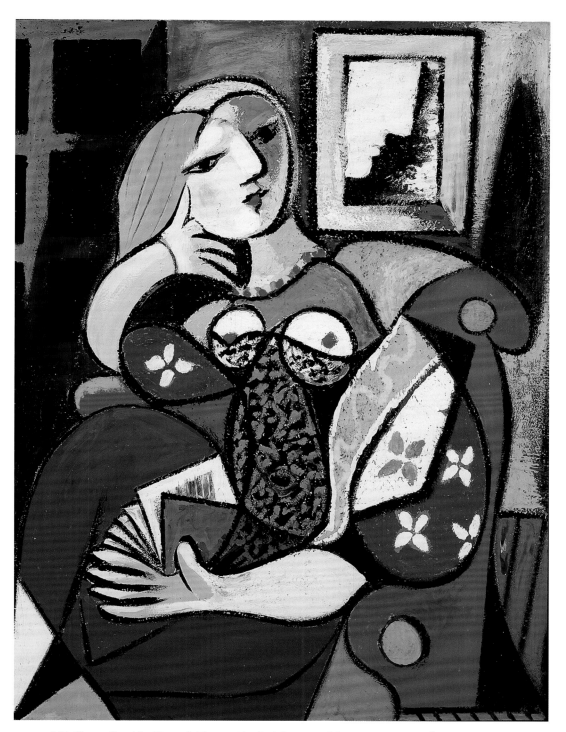

FIG. 15. Pablo Picasso (Spanish, 1881–1973). *Woman with a Book.* Paris, 1932. Oil on canvas, 51⅜ x 38½″ (130.5 x 97.8 cm).
THE NORTON SIMON FOUNDATION, PASADENA

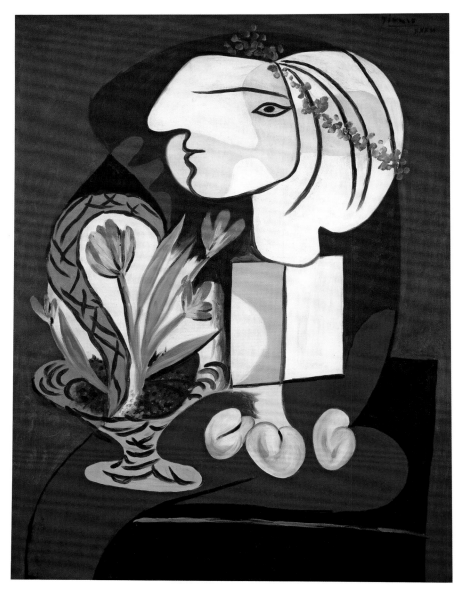

FIG. 16. Pablo Picasso (Spanish, 1881–1973). *Still Life with Tulips*. Paris, March 2, 1932. Oil on canvas, 63¾ x 51³⁄₁₆″ (162 x 130 cm). PRIVATE COLLECTION

Kahnweiler's words give us precious insight into Picasso's ambitions at this charged moment. To want to "paint like a blind man, who does a buttock by feel" suggests a desire to burrow inside physical sensation, to reconcile touching with looking, to describe something tactile in optical terms.[22] It is, in other words, to want to paint like a sculptor, in the most profound sense of the word.

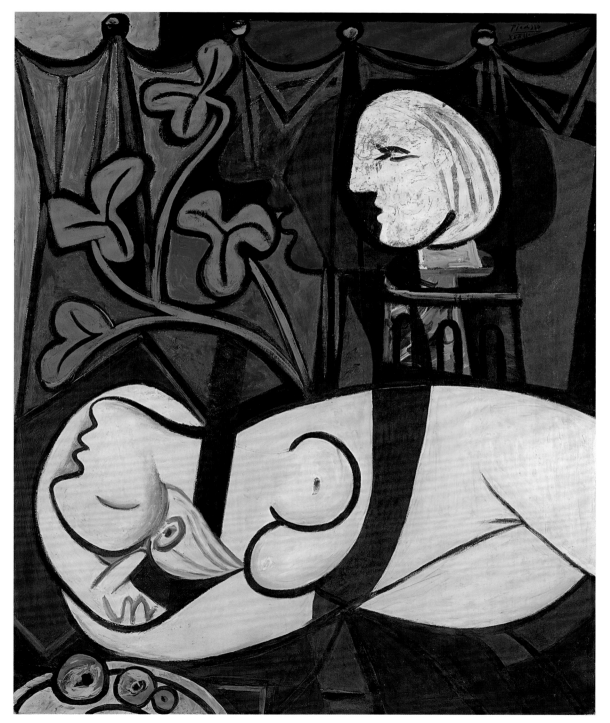

FIG. 17. Pablo Picasso (Spanish, 1881–1973). *Nude, Green Leaves, and Bust*. Paris, March 9, 1932. Oil on canvas, 63¾ x 51¹³⁄₁₆" (162 x 130 cm).

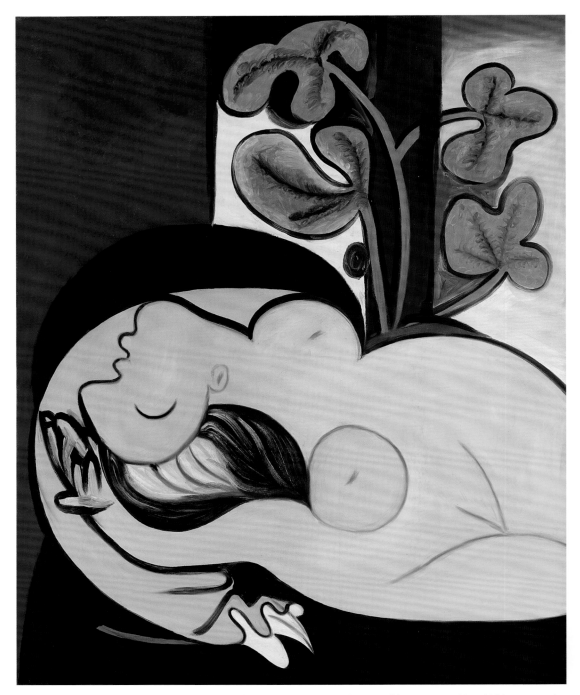

FIG. 18. Pablo Picasso (Spanish, 1881–1973). *Nude in a Black Armchair*. Paris, March 9, 1932. Oil on canvas, 63⅜ x 51³⁄₁₆″ (161 x 130 cm).
PRIVATE COLLECTION, U.S. COURTESY RICHARD GRAY GALLERY

OPPOSITE: FIG. 19. Pablo Picasso (Spanish, 1881–1973). *The Mirror*. Paris, March 12, 1932. Oil on canvas, 51¼ x 38⅛″ (130.2 x 96.8 cm).
PRIVATE COLLECTION

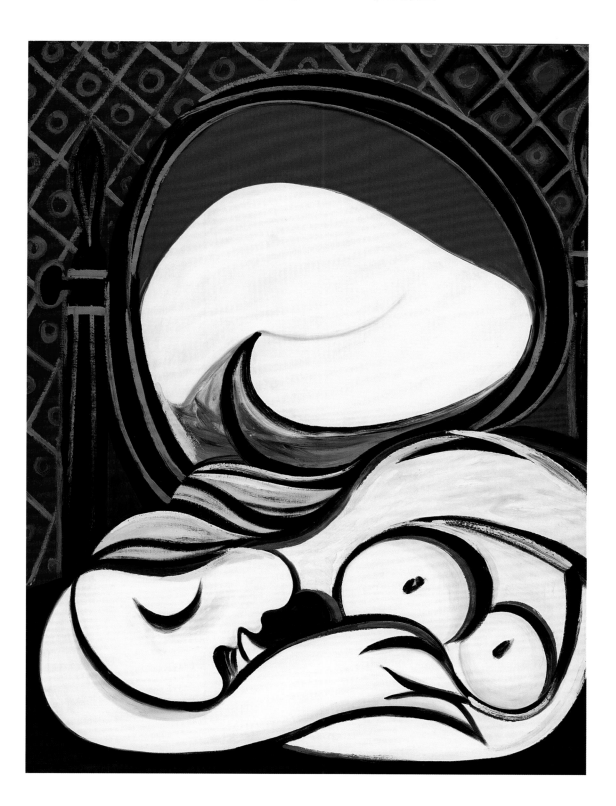

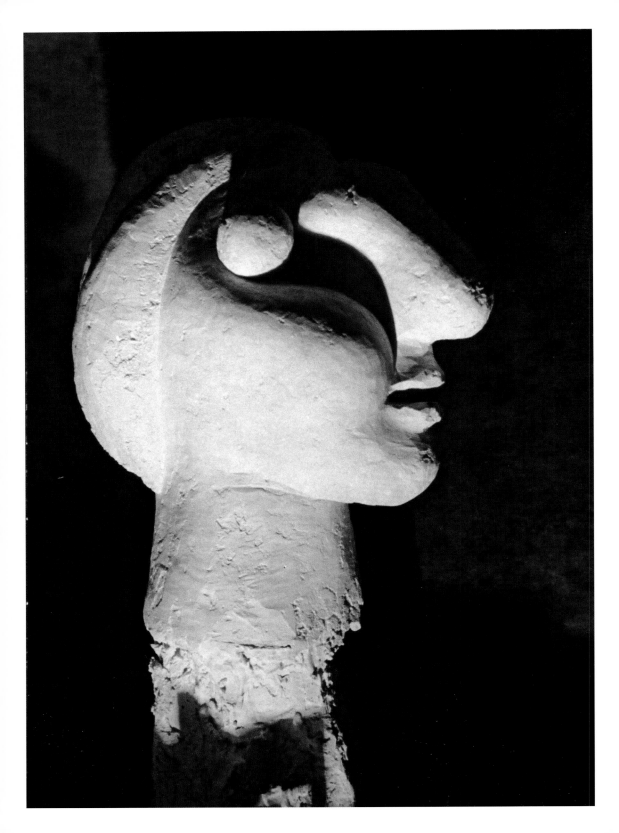

MIRROR IMAGES

It seems unlikely that *Girl before a Mirror* was one of the two recently finished paintings Kahnweiler saw on March 17. It displays none of the recumbent, liquid passivity of the sleeping figures of *Nude in a Black Armchair* and *The Mirror*, for example, each of which might be imagined as painted by "a satyr who had just killed a woman." The female protagonist of *Girl before a Mirror*, by contrast, is upright, wide-awake, and very much alive. She actively reaches out to embrace the mirror that frames her reflection. This reflected image has a paradoxical and pronounced physicality that seems distinctly sculptural, with paint, a liquid, used not just to fix a fleeting mirror image but also to solidify it, to turn it into stone. The simplified contours of the reflection's face and its crepuscular palette anticipate the dramatic effects of light and shadow captured in some of the nighttime photographs of Picasso's Boisgeloup plasters taken by the Surrealist photographer Brassaï [**FIG. 20**]. The treatment of the eye on the right, in particular, directly allies her painted image with Picasso's practice as a sculptor. Its circular form results from his having gouged out an upper layer of black paint, exposing a reddish-brown layer below, thus carving into his painting's surface to generate details, as he would have done when working with plaster.

The lower part of the reflection's body appears brightly lit, as though the top of the mirror were tilted back in space, casting the area above the girl's outstretched right arm into shadow. This arm and the curving, crescent-shaped, brown-red-and-black striped shadows that appear beneath it divide the mirror's surface horizontally into light and dark halves. The overall composition is similarly divided by one of the mirror's supporting pillars, which appears almost exactly in the middle of the painting, cleaving it in two. This vertical axis hinges the girl on the left, bearing Walter's distinctive hair and profile, to her oval-framed reflection on the right; the two figures, one physically present, the other nominally immaterial, confront each other across this central divide.[23] This rigorous formal organization, with two figures fitted into a design of four quasi-symmetrical lobes, creates a regular structure against which the curves of the model's head and body — and those of her reflection — register all the more strongly, including her ithyphallic left arm and testicular breasts, which continue the game of visual punning seen in other paintings from the Galeries Georges Petit series and in the plaster busts from Boisgeloup.

FIG. 20. Plaster of *Head of a Woman*, Boisgeloup, December 1932. Photo by Brassaï. ARCHIVES PICASSO, MUSÉE PICASSO, PARIS

Girl before a Mirror brings to mind a number of past masterpieces, all by artists Picasso is known to have revered: *The Rokeby Venus* (1647–51; **FIG. 21**), by the great seventeenth-century Spanish painter Diego Velázquez; *Madame Moitessier* (1856; **FIG. 22**), by the nineteenth-century French Neoclassical painter Jean-Auguste-Dominique Ingres; and *Before the Mirror* (1876; **FIG. 23**), by the Post-Impressionist Édouard Manet.[24] The artist whose work it most directly engages, however, is Picasso's deeply respected contemporary and rival, Henri Matisse. Matisse's own Galeries Georges Petit retrospective had opened on June 16, 1931, exactly one year before Picasso's, and had been judged by many to be a critical fiasco.[25] Among the many criticisms was that it included too many of his early 1920s Nice-period paintings, such as *Standing Odalisque Reflected in a Mirror* (1923; **FIG. 24**), which were scorned as leftover dealers' stock.

Picasso, however, seems to have been much more deeply impressed by Matisse's show than the critics; he is known to have studied all the exhibited works carefully, including those languid odalisques. In December 1931, when he turned from his Boisgeloup sculptures to painting, it was as though, as art

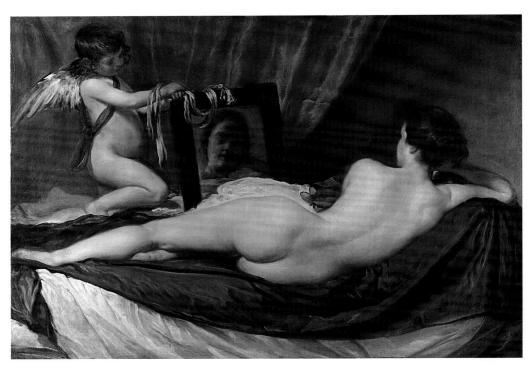

FIG. 21. Diego Velázquez (Spanish, 1599–1660). *The Toilet of Venus (The Rokeby Venus)*. 1647–51. Oil on canvas, 48¼ x 69¹¹⁄₁₆" (122.5 x 177 cm). THE NATIONAL GALLERY, LONDON. PRESENTED BY THE ART FUND

historian Yve-Alain Bois has written, he "chose to signify sensuality via a detour through Matisse's language."[26] Picasso did not hesitate to aggressively appropriate this language; he quoted the older artist in order to take possession of him, so radically reimagining his subjects and style that they became his own.[27] The saturated chromatic intensity, curving arabesque lines, and distinctive surface patterning of the paintings he produced for his own Galeries Georges Petit exhibition make them among the most Matisse-like of his works; at the same time, their strident color combinations and palpable eroticism redefine Matisse's art in more hotly sexualized terms.[28]

The relationship between Matisse's *Standing Odalisque Reflected in a Mirror* and Picasso's *Girl before a Mirror* offers a particularly vivid case in point. Both paintings feature a female figure standing before a mirror in an extravagantly patterned interior. Picasso's painting, however, is almost two times larger, electric in palette, and designed for public presentation; it is more intense than Matisse's quiet, more conventionally naturalistic image in every possible way. The mirror in Matisse's composition, for example, offers additional visual information about

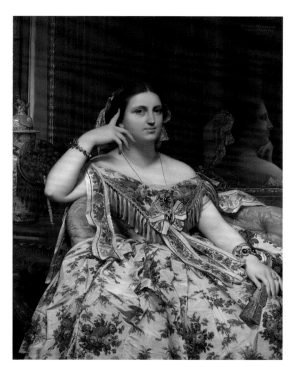

FIG. 22. Jean-Auguste-Dominique Ingres (French, 1780–1867). *Madame Moitessier*. 1856. Oil on canvas, 47¼ x 36¼" (120 x 92.1 cm). THE NATIONAL GALLERY, LONDON. PURCHASE

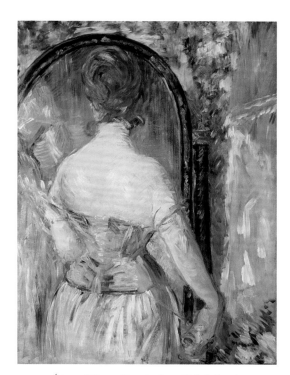

FIG. 23. Édouard Manet (French, 1832–1883). *Before the Mirror*. 1876. Oil on canvas, 36¼ x 28⅛" (92.1 x 71.4 cm). SOLOMON R. GUGGENHEIM MUSEUM, NEW YORK. GIFT OF JUSTIN K. THANNHAUSER

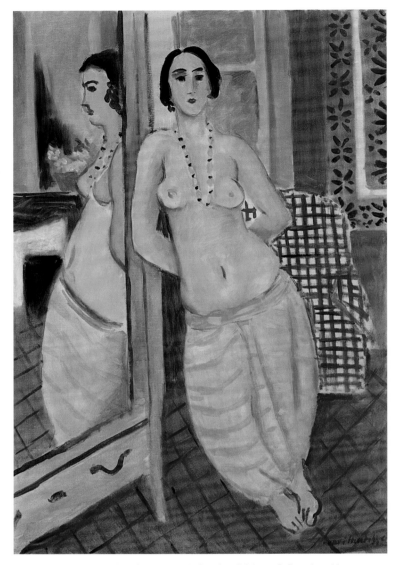

FIG. 24. Henri Matisse (French, 1869–1954). *Standing Odalisque Reflected in a Mirror*. 1923. Oil on canvas, 31⅞ x 21⅜″ (81 x 54.3 cm). BALTIMORE MUSEUM OF ART. THE CONE COLLECTION, FORMED BY DR. CLARIBEL CONE AND MISS ETTA CONE OF BALTIMORE

the room in which his odalisque stands. Picasso's mirror shuns such contextual particularities. It reflects only his singular subject, whom the artist has zoomed in on obsessively, fetishistically even, excluding all peripheral details.

Only the brightly colored diamond-patterned wallpaper in *Girl before a Mirror* offers a hint of the model's location or situation: it has been identified by Picasso's biographer, John Richardson, on the basis of a small, rapidly executed

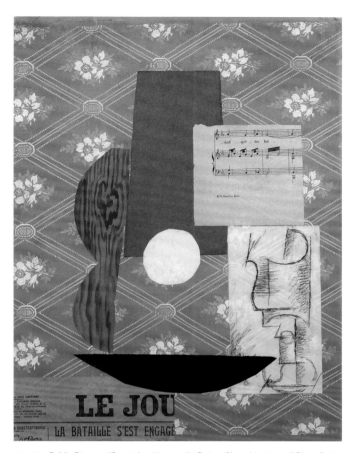

FIG. 25. Pablo Picasso (Spanish, 1881–1973). *Guitar, Sheet Music, and Glass.* Paris, November 18, 1912 (or later). Cut-and-pasted paper, charcoal, and gouache on paperboard, 18⅞ x 14¾" (47.9 x 37.5 cm). MCNAY ART MUSEUM, SAN ANTONIO. BEQUEST OF MARION KOOGLER MCNAY

oil sketch, as similar to that found in the small apartment on the rue de Liège where Picasso and Walter used to meet.[29] Its pattern can also be compared, more generally, to that of the found pieces of wallpaper that appear in some of his Cubist collages **[FIG. 25]** and to that of the prosaic tiled floor in Matisse's painting, here reimagined as a vibrant, quasi-animate diamond lattice that takes over the picture's entire background. The wallpaper's changes in hue from left to right are but one indication that particularities of place and biographical specifics have been left far behind and that the space inhabited by Picasso's girl and her reflection has been transformed into a mythic domestic interior, emblazoned with a pattern recalling the costume of Harlequin, a commedia dell'arte character that Picasso identified with, insinuating the artist's presence into this cloistered, feminine realm.[30]

Another telling difference between Picasso's and Matisse's paintings is found in the space that separates their respective models from their reflections. In both cases this area is occupied by the mirror's frame and supporting stand. Matisse represents his mirror's frame as a continuous line that definitively separates his model's right shoulder and arm from their mirrored counterparts. Reflected space within the mirror and exterior physical space within which the model stands are cordoned off from each other, illustrating the art historian Leo Steinberg's observation that

> a mirror reflection, after all, is always elsewhere. Its identity with the thing mirrored is not grasped by intuition, but inferred from relational clues. Whether addorsed or confronted, a girl's mirror image widens the gap between her knowable aspects. Object and image repel one another. Even if carefully hyphened by means of proximity and obvious likeness, they do not cohere. They want to diverge from each other like one's own two hands back to back.[31]

Steinberg went on to remark that Picasso, however, "seems to regard this [gap] as a fault that requires correction."[32] This same area in his painting is filled with intersecting lines and shifts in color that interrupt the vertical continuity of his mirror's black, blue, and orange contours. These lines and color changes cause his model's right arm to morph from lavender-pink flesh into a multicolored reflection, which magically escapes the confines of the mirror's frame and crosses over into real space. This arm's defining lines, and those of the striped shadows that appear beneath it and the model's breasts, lock the girl and her reflected image together in a continuously complex embrace that is perceptual and per-petual, visually and spatially shifting.

X-rays reveal that the girl in the painting began life with her back to us [FIG. 26]. Her curvaceous buttocks and hips were outlined naturalistically, recall-ing Picasso's etched *Partial Female Figure* [FIG. 27], reproduced as a headpiece for Ovid's *Les Métamorphoses*, which he had illustrated the previous year and included in his exhibition at the Galeries Georges Petit.[33] In this early state, her pose bore some resemblance to that of the woman in Manet's *Before the Mirror*, which also includes a cheval mirror.[34] From the start, however, Picasso placed his model and her mirror on opposite sides of the composition, so that our view of the reflection that appears within the mirror of his model's body and face remains unobstructed, unlike in Manet's painting, where the body of the model blocks its reflected counterpart from view. And Picasso had his model physically engage with the mirror and her reflection, rather than just passively admiring herself, thus creating a more psychologically intense image.

FIG. 26. X-ray of *Girl before a Mirror*, taken in 2011

Livre XIV

FIG. 27. Pablo Picasso (Spanish, 1881–1973). *Partial Female Figure,* headpiece from Édition Skira's *Les Métamorphoses* by Ovid. 1931. Etching, plate: 5¼ x 6⁹⁄₁₆″ (13.3 x 16.6 cm). THE MUSEUM OF MODERN ART, NEW YORK. PURCHASE, 1945

FIG. 28. Pablo Picasso (Spanish, 1881–1973). *Bathers with Beach Ball.* Dinard, August 21, 1928. Oil on canvas, 6¼ x 8¾" (16 x 22 cm). PRIVATE COLLECTION

Judging from *Girl before a Mirror*'s finished state, Picasso painted rapidly and vigorously over his initial composition, using a combination of oil paints and quick-drying household enamels. By applying heavy lines of black paint over previously dry layers, he disrupted the original, continuous sweep of the girl's right arm, out-lining her breasts and adding a black-contoured green circle where the right arm had crossed the left. He also dramatically altered the profile of her buttocks and hips, making their soft curves conform to the angles of the diamond-patterned wallpaper and giving them an oddly geometric hourglass form. He used the same black paint to cover the girl's left side with a series of horizontal lines that recall the stripes of bathing suits seen in some of his 1928 Dinard beach paintings **[FIG. 28]** and the distinctive striped pattern of the shadows cast on the wall of his studio at Boisgeloup **[FIG. 29]**.[35] He painted a bold circle over what was initially

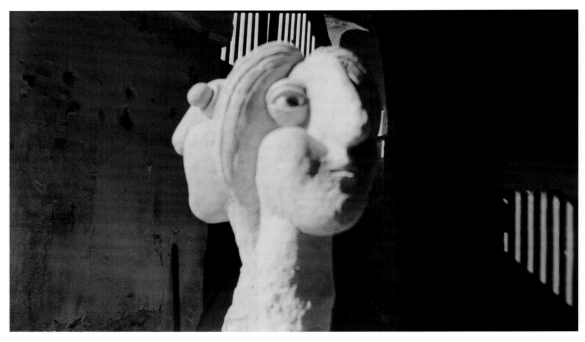

FIG. 29. *Head of a Woman* and *Bust of a Woman* in the sculpture studio at Château de Boisgeloup, 1931. Photographer unknown. ARCHIVES OLGA RUIZ-PICASSO. COURTESY FUNDACIÓN ALMINE Y BERNARD RUIZ-PICASSO PARA EL ARTE

the girl's slightly raised left buttock, and he silhouetted the right one in a way that transformed what was readily identifiable as a curvaceous rear cheek into a shape that doubles as a belly, causing some art historians to speculate that the girl is pregnant and that the circled area represents a womb.[36]

Whether or not Picasso intended to provoke such a literal reading, it is clear that his alterations make it possible to interpret this part of the girl's body as both a side and rear view. The mirror reflection of her nether regions makes the view even more improbably complex, with breasts, belly, vulva, buttocks, and hips all impossibly present. *Sleeping Nude* [**FIG. 30**], a provocatively unfinished charcoal on canvas from around this same period, presents a comparable conflation of front and back views. Its ghostly lines register a sense of shifting, slowly turning sensuous movement that *Girl before a Mirror* freezes, preserving it in fixed form for public delectation and voyeuristic scrutiny. "There is no abstract art. You must always start with something," Picasso remarked a few years later.[37] The X-ray of *Girl before a Mirror* makes it possible for us to watch Picasso put his words to work, by using the contours of the original, naturalistic composition as guidelines and points of departure for what became a highly stylized, complex, and multivalent work of art.

FIG. 30. Pablo Picasso (Spanish, 1881–1973). *Sleeping Nude.* Paris, 1932. Charcoal on gessoed canvas, 38¼ x 51¼" (97 x 130 cm). PRIVATE COLLECTION. COURTESY GAGOSIAN GALLERY

GIRL BEFORE A MIRROR GOES ON VIEW

Girl before a Mirror made its first public appearance on June 15, 1932, at the posh opening of the artist's retrospective at the Galeries Georges Petit. It can be glimpsed in a photograph taken at the opening reception [**FIG. 31**], where it appears partially obscured by a large floral arrangement, with the heads of the girl and her mirror reflection peeking up above those of guests seated on a large couch in the center of the room. The artist, who personally took charge of the installation, placed it in the Grande Salle, a huge, rectangular room with

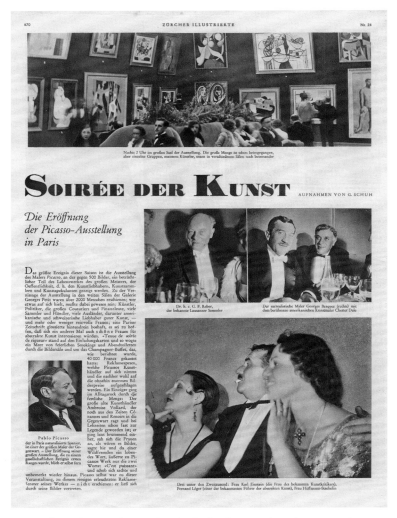

FIG. 31. "Soirée der Kunst," an article in the *Zürcher Illustrierte* about the opening of Picasso's Galeries Georges Petit exhibition, with *Girl before a Mirror* shown just behind a floral arrangement, June 1932

walls covered in dark-red fabric that he double-hung with some seventy paintings, including most of his recent Walter-inspired series [**FIG. 32**].[38] *Girl before a Mirror* was installed at eye level, on a wall that included works as early as his 1923 Neoclassical masterpiece, *The Pipes of Pan*, and as recent as *Woman with a Flower*, completed on April 10, 1932. Picasso deliberately installed his retrospective achronologically, wanting to emphasize the continuity of ideas throughout the varied styles of his oeuvre.[39] The overall effect of the exhibition, which filled multiple rooms at the Galeries Georges Petit and included some 225 paintings and works on paper, 7 sculptures, and 6 illustrated books, must have been overwhelming, subsuming the powerful particularities of individual works.

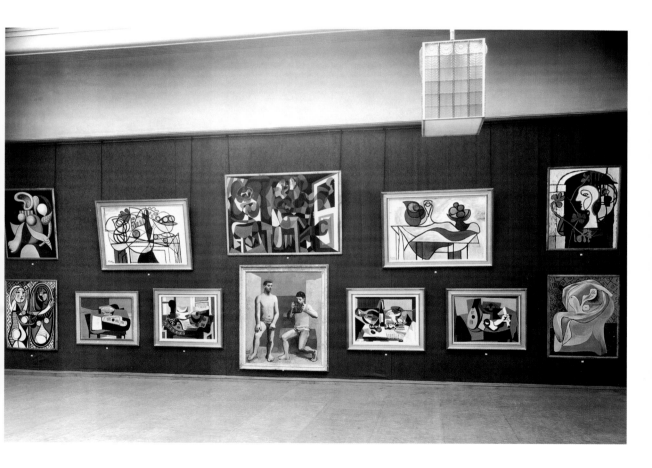

FIG. 32. Installation view of *Exposition Picasso*, Galeries Georges Petit, Paris, 1932. KUNSTHAUS ZÜRICH, FOTOSAMMLUNG

After Paris the exhibition traveled to Switzerland, where it was presented at the Kunsthaus Zürich and infamously reviewed by the psychologist and psychotherapist Carl Gustav Jung.[40] Believing, apparently, that the works on view offered transparent, unmediated access to the depths of Picasso's psyche, Jung diagnosed the artist as a schizophrenic:

> After the symbols of madness experienced during the period of disintegration, there follow images which represent the coming together of opposites. . . . One painting [likely *Girl before a Mirror*] (although traversed by numerous lines of fracture) even contains the conjunction of the light and dark anima.[41]

Although many art historians have taken issue with this diagnosis, Jung was in fact the first to draw attention to Picasso's genius for fusing opposites, which is what gives his bifurcated composition and the enigmatic relationship between its two protagonists — the bright-haired girl and her dark reflection — such enduring fascination and power.

Barr traveled to Zurich to see the show and ranked the works on view, giving *Girl before a Mirror* an A, although he did not pursue its purchase at the time.[42] Several years later, *Girl before a Mirror* was consigned by Picasso's Paris dealer, Paul Rosenberg, to New York's Valentine Gallery. In late 1937 Mrs. Simon Guggenheim offered the Museum a gift of ten thousand dollars to purchase a major work of art for the collection, and she clearly stated a preference for Valentine Gallery stock.[43] Working within these restrictions, Barr selected *Girl before a Mirror*, telling A. Conger Goodyear, the Museum's first president, on December 16, 1937, that he considered it "the finest Picasso of the past ten years."[44] The work was acquired by the Museum shortly thereafter. From the moment it arrived, it was recognized as a consummate masterpiece, subject to reverential treatment— even its routine measurement and condition checking by the Museum's registrars was photographically documented [FIG. 33]. On Monday, January 24, 1938, it went on public display.[45] During World War II and in the decade that followed, it was frequently installed in a prominent position at the entrance to the Museum's collection galleries [FIG. 34], and its identity (and Picasso's) became indelibly associated with that of the institution, where it remains among the most popular paintings in the collection to this day.

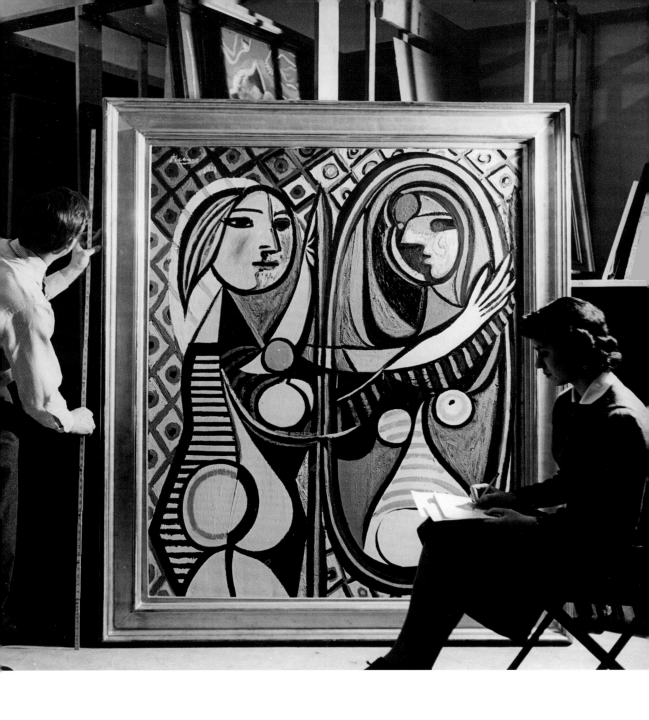

FIG. 33. *Girl before a Mirror* being catalogued in the Department of the Registrar, The Museum of Modern Art, New York, 1938. PHOTOGRAPHIC ARCHIVE, THE MUSEUM OF MODERN ART ARCHIVES, NEW YORK

FIG. 34. Entrance to The Museum of Modern Art's Painting and Sculpture Collection Galleries, 1945–46. PHOTOGRAPHIC ARCHIVE, THE MUSEUM OF MODERN ART ARCHIVES, NEW YORK

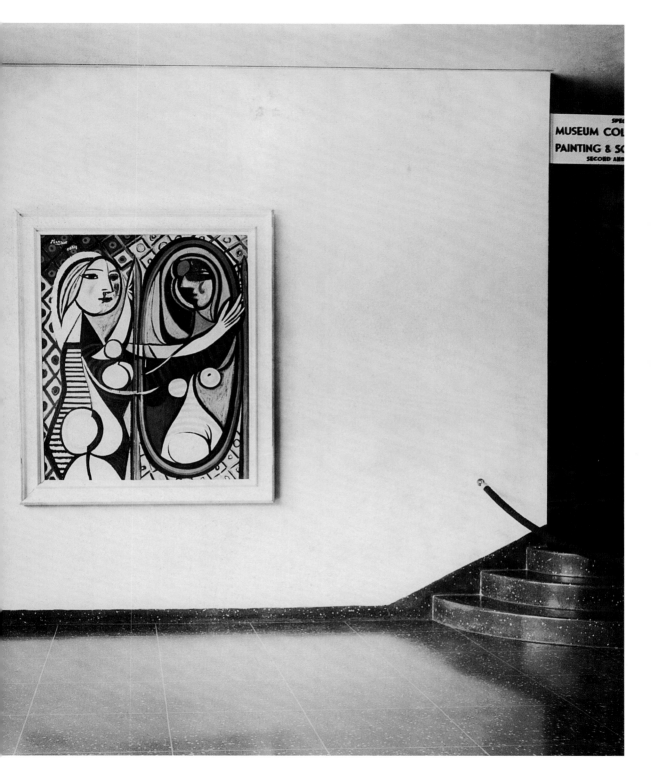

NOTES

1. Although *Girl before a Mirror* was placed on a new stretcher in 1957 and relined in 1964, recent infrared pictures of the verso suggest the original canvas was inscribed "32 14/mars," which would correspond with the dated inscription recorded in early published mentions of the paintings. My thanks to MoMA conservators Cindy Albertson, Anny Aviram, Michael Duffy, and Kristin Robinson for their time and skill in examining and X-raying the painting and for their many thoughtful insights.

2. For an excellent account of this series, see Michael Fitzgerald, "A Question of Identity," in *Picasso's Marie-Thérèse* (New York: Acquavella Galleries, 2008), pp. 8–29.

3. Robert Rosenblum, "Picasso's Blond Muse: The Reign of Marie-Thérèse Walter," in William Rubin, ed., *Picasso and Portraiture: Representation and Transformation* (New York: The Museum of Modern Art, 1996), p. 354.

4. "L'oeuvre qu'on fait est une façon de tenir son journal." Pablo Picasso, quoted in E. Tériade, "En causant avec Picasso," *L'Intransigéant*, June 15, 1932, p. 1.

5. On preparations for Picasso's retrospective at Galeries Georges Petit, see Yve-Alain Bois, *Matisse and Picasso* (Fort Worth: Kimbell Art Museum, 1998), pp. 66–75. See also Fitzgerald, "A Question of Identity," pp. 24–27.

6. Alfred H. Barr, Jr., *Picasso: Forty Years of His Art* (New York: The Museum of Modern Art, 1939), p. 156.

7. For an illuminating account of their relationship, see Diana Widmaier Picasso, "Marie-Thérèse Walter and Pablo Picasso: New Insights into a Secret Love," in Markus Müller, ed. *Picasso and Marie-Thérèse Walter: Between Classicism and Surrealism* (Münster: Graphikmuseum Pablo Picasso Münster, 2004), pp. 27–35.

8. Walter, interview with Pierre Cabanne on the radio broadcast *Présence des arts*, April 13, 1974; translated in Diana Widmaier Picasso, "Marie-Thérèse Walter and Pablo Picasso," p. 28.

9. Pierre Daix, *Dictionnaire Picasso* (Paris: Robert Laffont, 1995), p. 901.

10. Picasso would sometimes include a P in his coded inscriptions, fusing it with MT; one might also see the upended M as a W, for Walter. On Picasso's cryptograms, see Rosenblum, "Picasso's Blond Muse," pp. 338–39.

11. Diana Widmaier Picasso, "Marie-Thérèse Walter and Pablo Picasso," pp. 29–30.

12. Françoise Gilot and Carlton Lake, *Life with Picasso* (New York: McGraw-Hill, 1964), p. 241.

13. Ibid., pp. 241–42.

14. On the lithograph published with André Level's book, *Picasso* (Paris: G. Crès, 1928), see Rosenblum, "Picasso's Blond Muse," p. 338.

15. In the summer of 1928 Picasso rented a cabana for trysts with Walter; the scholar Lydia Gasman was the first to suggest that this beachside refuge could have served as a symbol for their illicit affair. Gasman, "Mystery, Magic, and Love in Picasso, 1925–1938: Picasso and the Surrealist Poets," 4 vols. (PhD diss., Columbia University, 1981).

16. In 1928 Picasso modeled two small plasters in preparation for designing a monument to his friend, the poet Guillaume Apollinaire, but the many plaster sculptures made at Boisgeloup constitute a much more sustained engagement with the practice of modeling.

17. On Picasso's work as a sculptor, see Elizabeth Cowling, "The Image of Picasso–Sculptor in the 1930s," in John Richardson and Diana Widmaier Picasso, eds., *Picasso and Marie-Thérèse Walter: L'Amour fou* (New York: Gagosian Gallery, 2011), pp. 256–91.

18. Picasso, quoted in André Warnod, "En peinture tout n'est que signe, nous dit Picasso," *Arts* 22 (June 29, 1945). Translation by Blair Hartzell.

19. On Picasso's relationship with Surrealism, see Anne Baldassari, *The Surrealist Picasso* (Paris: Fondation Beyeler, 2005).

20. Cowling, "The Sculptor's Studio: Picasso's *Bust of a Woman*," in *Picasso's Marie-Thérèse*, pp. 35–37.

21. Daniel-Henry Kahnweiler, letter to Michel Leiris, March 19, 1932; published in Isabelle Monod-Fontaine, *Donation Louise et Michel Leiris: Collection Kahnweiler-Leiris* (Paris: Centre Georges Pompidou, 1984), p. 192; translated in Richardson, *A Life of Picasso: The Triumphant Years, 1917–1932* (New York: Knopf, 2007), p. 470. Since Kahnweiler mentions having seen Picasso two days earlier, Richardson dates his visit to Picasso's Paris studio to March 17.

22. I am indebted to Leo Steinberg's insightful discussion of Picasso's "continual struggle in the *Femmes d'Alger* series to reconcile distance with presence, possessing and watching, the data

of vision and the carnal knowledge attained in an embrace. Sight, which needs distance, is out of touch with its aim. Whereas the embrace, having lost distance, is blind." Steinberg, *Other Criteria: Confrontations with Twentieth-Century Art* (New York: Oxford University Press, 1972), p. 130.

23. John Elderfield describes the "hinged composition" of this painting in Cowling et al., *Matisse/Picasso* (London: Tate Publishing; Paris: RMN; New York: The Museum of Modern Art; 2003), p. 238.

24. On Picasso's conjuring of the "ghosts of mirrors past," and for significant references and precedents, see Rosenblum, "Picasso's Blond Muse," pp. 350–60; and his earlier "Picasso's *Girl before a Mirror*: Some Recent Reflections," *Source: Notes in the History of Art* 1, no. 3 (Spring 1982): 1.

25. On the poor reviews Matisse received from the press, see Bois, *Matisse and Picasso*, pp. 64–66. On Picasso's sustained involvement in planning his own retrospective, see Richardson, *A Life of Picasso*, pp. 475–79; and Simonetta Fraquelli, "Picasso's Retrospective at the Galeries Georges Petit, Paris, 1931: A Response to Matisse," in Tobia Bezzola, ed., *Picasso: His First Museum Exhibition, 1932* (Zurich: Kunsthaus Zürich, 2010), pp. 78–80.

26. Bois, *Matisse and Picasso*, p. 64.

27. On the issue of artistic appropriation and give-and-take between the two artists, see Elderfield, *Matisse/Picasso*, p. 234.

28. On the Matissean qualities of Picasso's work in this period, see Bois, *Matisse and Picasso*, pp. 58–75.

29. The work Richardson connects with Picasso's rue de Liège love nest is *Reclining Nude* (Paris, April 3, 1929). See Richardson, *A Life of Picasso*, p. 467.

30. On Picasso's Harlequin alter ego, see Rosenblum, "Picasso's Blond Muse," p. 359.

31. Steinberg, *Other Criteria*, p. 181.

32. Ibid.

33. Many thanks to Blair Hartzell for bringing this etching to my attention.

34. On the connection to Édouard Manet and other mirror images in the history of painting, see Rosenblum, "Picasso's Blond Muse," p. 358.

35. William Rubin has connected the darker bands in the painting to striped fabric. See Rubin, *Picasso in the Collection of The Museum of Modern Art* (New York: The Museum of Modern Art, 1972), p. 138.

36. For descriptions of the figure's belly or womb, see Reinhold Hohl, "C. G. Jung on Picasso (and Joyce)," *Source: Notes in the History of Art* 3, no. 1 (Fall 1983): 10–18. See also Rubin, *Picasso in the Collection of The Museum of Modern Art*, pp. 138–41.

37. Picasso, quoted in Christian Zervos, "Conversation avec Picasso," *Cahiers d'art* 10 (1935): 174; republished as "Statement by Picasso: 1935," in Barr, *Picasso*, p. 16.

38. On the installation at Galeries Georges Petit, see Fraquelli, "Picasso's Retrospective at the Galeries Georges Petit, Paris, 1932," pp. 77–93.

39. On possible motives behind his achronological installation, see ibid., pp. 89–91.

40. Carl Jung, "Picasso," *Neue Zürcher Zeitung* 153, no. 2,107 (November 13, 1932): 2. On Jung's diagnosis of Picasso, see Christian Geelhaar, "Picasso: The First Zurich Exhibition," in Bezzola, ed., *Picasso*, pp. 38–41.

41. Jung, "Picasso," p. 2

42. Barr's heavily annotated catalogue is in The Museum of Modern Art Archives, New York, Alfred H. Barr, Jr., Papers, 12a.6.

43. E. M. Lundell, on behalf of Mrs. Simon Guggenheim, letter to Barr, December 3, 1937, The Museum of Modern Art, New York, Department of Painting and Sculpture, Museum Collection Files.

44. Barr, letter to A. Conger Goodyear, December 16, 1937, The Museum of Modern Art, New York, Department of Painting and Sculpture, Museum Collection Files.

45. Press release, The Museum of Modern Art, New York, January 24, 1938.

FOR FURTHER READING

Barr, Jr., Alfred H. *Picasso: Forty Years of His Art.* New York: The Museum of Modern Art, 1939.

Bezzola, Tobia, ed. *Picasso: His First Museum Exhibition, 1932.* Zurich: Kunsthaus Zürich, 2010.

Bois, Yve-Alain. *Matisse and Picasso.* Fort Worth: Kimbell Art Museum, 1998.

Cowling, Elizabeth, et al., *Matisse/Picasso.* London: Tate Publishing; Paris: RMN; New York: The Museum of Modern Art, 2003.

Gilot, Françoise, and Carlton Lake. *Life with Picasso.* New York: McGraw-Hill, 1964.

Müller, Markus, ed. *Picasso and Marie-Thérèse Walter: Between Classicism and Surrealism.* Münster: Graphikmuseum Pablo Picasso Münster, 2004.

Picasso's Marie-Thérèse. New York: Acquavella Galleries, 2008.

Richardson, John. *A Life of Picasso: The Triumphant Years, 1917–1932.* New York: Knopf, 2007.

Richardson, John, and Diana Widmaier Picasso, eds. *Picasso and Marie-Thèrése: L'Amour fou.* New York: Gagosian Gallery, 2011.

Rubin, William, ed. *Picasso and Portraiture: Representation and Transformation.* New York: The Museum of Modern Art, 1996.

Produced by The Department of Publications
The Museum of Modern Art, New York

Edited by Emily Hall
Designed by Miko McGinty and Rita Jules
Production by Matthew Pimm
Printed and bound by Oceanic Graphic Printing, Inc., China

Typeset in Ideal Sans
Printed on 157 gsm Gold East Matte Artpaper

Library of Congress Control Number: 2012935387
ISBN: 978-0-87070-829-9

Published by The Museum of Modern Art
11 West 53 Street
New York, New York 10019-5497
www.moma.org

Distributed in the United States and Canada by ARTBOOK | D.A.P.,
155 Sixth Avenue, 2nd floor, New York, New York 10013
www.artbook.com

Distributed outside the United States and Canada by Thames & Hudson Ltd.,
181A High Holborn, London WC1V 7QX
www.thamesandhudson.com

Printed in China